How to Take Good Pictures

How to Improve Your Photography

Easy to Follow Tips for Taking Better Pictures

By

Marilyn Banyai

MyFruitfulVentures@gmail.com

CONTENTS

1. Your Tools…………..……...10
2. Empty Space……………......14
3. Your Position……………......16
4. Background……………........18
5. Your Surroundings………......24
6. Babies...28
7. Other People……………........34
8. Pets & Other Living Creatures..36
9. Lighting…………………........40
10. Contrast……………….….....42
11. Framing……………….…......46
12. Lines………………………....48
14. Off Center…………….….....52
15. Angles………………….…....54
16. Practice Makes Perfect…….....58

Have you ever gotten home from a great vacation anxious to show your pictures to friends and family - only to be disappointed that they didn't express the true beauty of the places you visited? I have! If you're reading this book, you probably love to take pictures, but you're not always happy with the way your photos turn out.

Photography isn't about perfection. It's about capturing images that will be pleasing to you and those you want to share the pictures with.

So - how do you make your pictures great? Every picture should tell a story. What do you want your pictures to say? How do you want your viewers to feel? Instead of trying to take perfect pictures, try to make them energetic, curious, or fascinating. Practice with your camera. Take it with you everywhere you go. Try new things. Be creative.

This book isn't about taking perfect, professional pictures. It's about the little things you can do to make your pictures more interesting to look at, and not letting your subjects melt into the background of your photos.

Here are some tips on taking shots that tell great stories.

Your Tools

Of course you need to have a camera to take pictures. But - no matter what kind of camera you're using, your most important tools in good photography are your eyes. The first thing you should do is study photos in books, magazines or websites that you enjoy.

What do you like about them? What makes them different - the angles, time of day, lighting? Is the setting sun shining on the side of the building? Is the rising sun shining on the hill or tree in the background? Are there shadows or reflections creating interesting patterns? Are there puffy cloud formations in the sky?

Are there people in the pictures? What are they doing? Most likely, they're not just standing still and posing.

Take some time to observe people around you or children at play. Watch the expressions on their faces. Observe the interaction between them as they play.

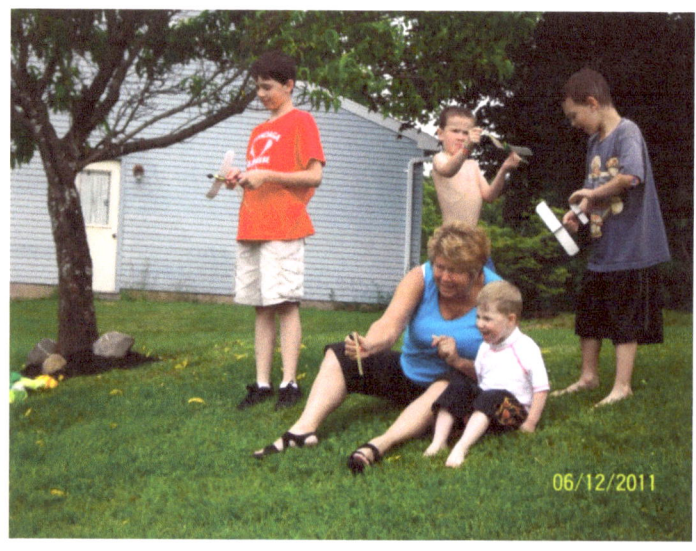

Watch animals frolicking in the yard. My cat often chases bugs in the grass and takes on some very interesting positions in the process. My dog likes to chew on his toy chipmunk, trying to make it squeak.

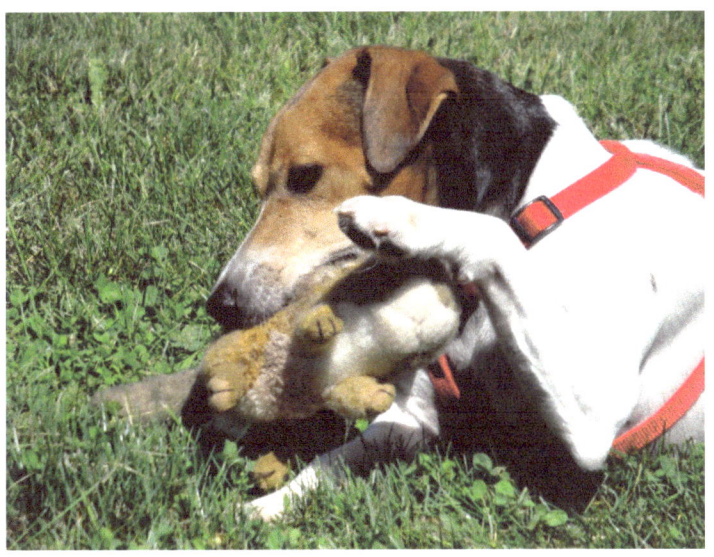

Pay attention to the little things that you may have seen countless times - they could make great pictures. Think about how you would like to capture those visions. If you can't find anything you want to

photograph in front of you, try turning around. There may be a great shot behind you.

Photographer Ernst Haas has been quoted saying "Don't take pictures, be taken by pictures." Photographer Vincent Versace added to that, "Allow yourself to experience the entire moment…Slow down enough so when you're looking through the camera, that picture takes you.

Empty Space

Choose a primary point of interest before taking the picture. Determine which area is most important to you and compose the picture around that area. Get closer. Zoom in. Don't end up with 2 or 3 tiny figures in the very center of the shot, surrounded by acres of space. In good photos, you can recognize what (or who) the subject is, the eyes are open and their heads are fully in the picture. Good pictures are pleasing to look at in good focus.

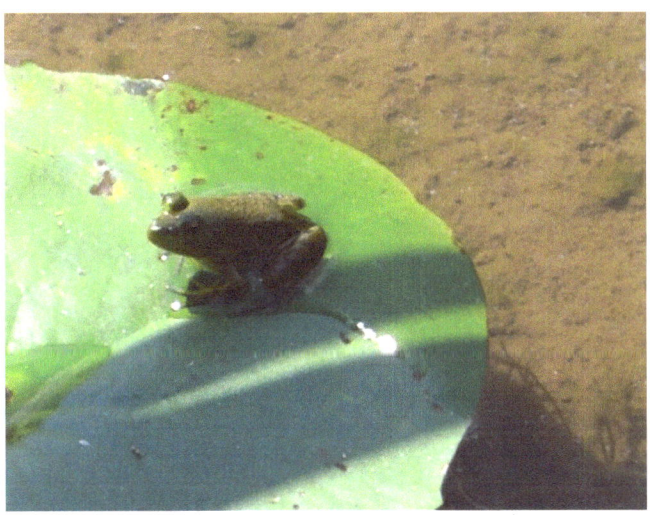

If you're taking pictures of flowers, don't be afraid to zoom in on one blossom, maybe one with a busy bee drinking it's nectar. Head and shoulder shots of loved ones are good, especially with great scenery in the background. Have them move closer to you before you shoot. With a digital camera and a good memory card, you can take countless pictures to figure out which ones work for you, the ones you enjoy the most.

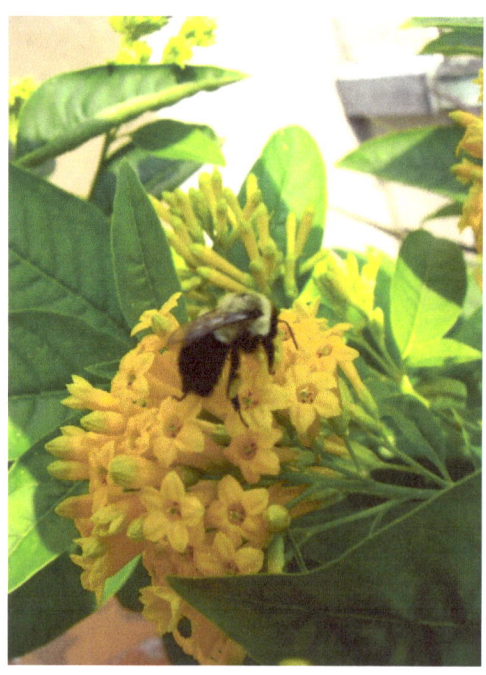

Your Position

Consider your position in relation to the subject (the thing or person you are photographing). Take pictures of a fixed object from different points of view: crouch down, sit on the ground or the floor, stand on a chair, move in closer or step farther away. Shoot the picture from the right side, from the left, through a gate, through a tree, etc.

Pay attention to the details. Before you snap your picture, take a minute to look around you to see if there is a better angle to shoot from, to see if there's more color in the background on the left of the subject than there is on the right.

Taking pictures from different angles, in different lighting and from various distances makes each picture look unique. Develop an eye for detail.

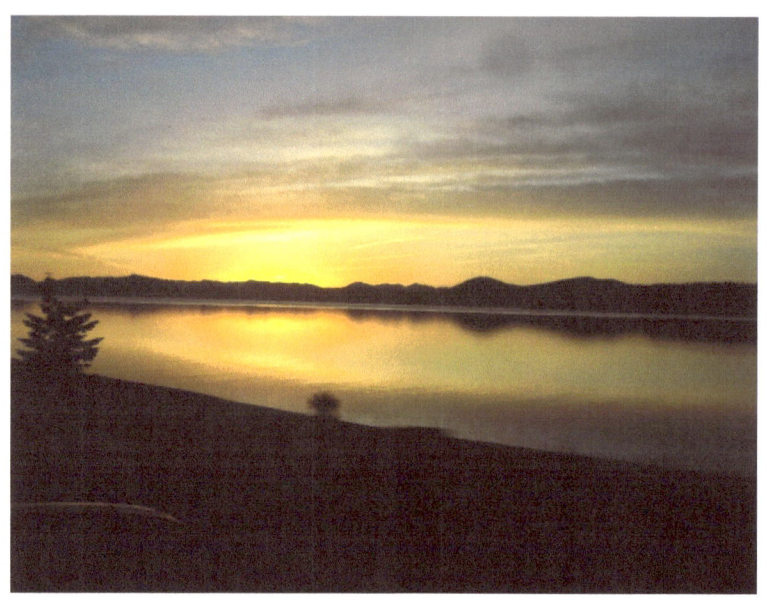

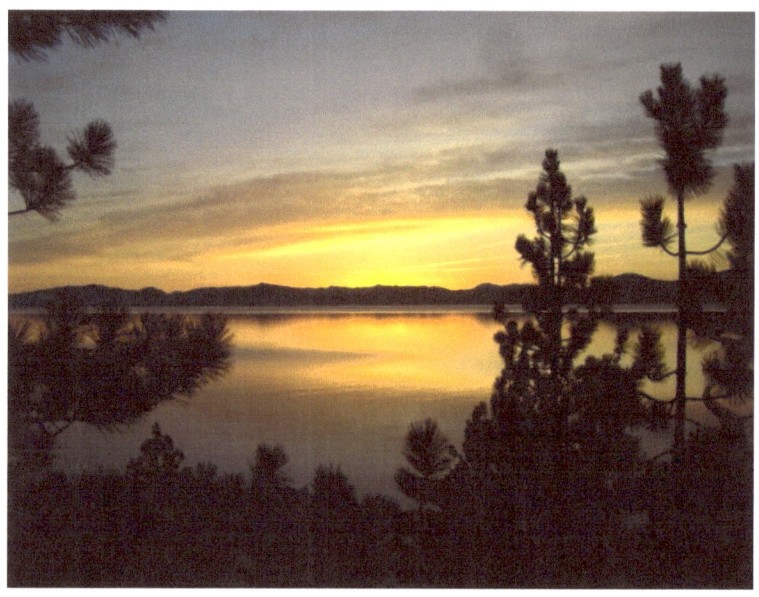

These photos were taken from different angles, just a few feet apart.

Background

Be sure that only the things you want the viewer to see appear in the picture. If there are numerous objects cluttering up the background, your message will be lost.

Look around before you snap the picture. Are there things in the picture that will detract from it - a Coke can or candy wrapper lying under that rock in the foreground? Finding a unwanted object in your picture can be disappointing, but it happens. But, sometimes it works the other way. In this picture, I was trying to photograph the sky and was thrilled after I took it to see the legs dangling from the ride above me.

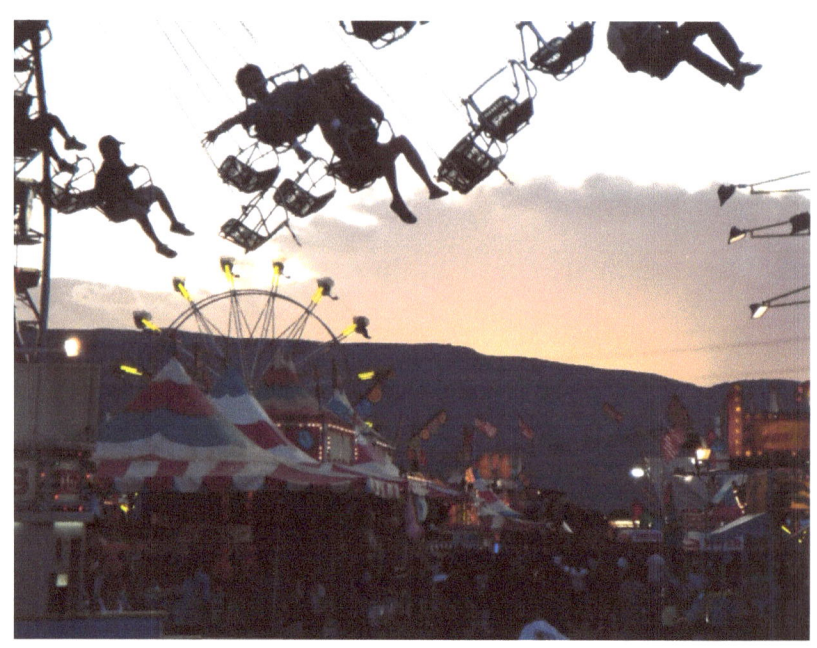

What do you see behind your subject? Are there mountains, hills, trees, water? Is the sun rising or setting? Are there patterns affected by the lighting, leaves turning over or changing colors, shadows on the ground? Is there an interesting rock formation, or cloud pattern or tree in the area that could make the picture more interesting or playful?

Look for the colors in front of you - green trees, red brick buildings, blue sky, green grass or brown hillsides. How will these colors affect or frame your

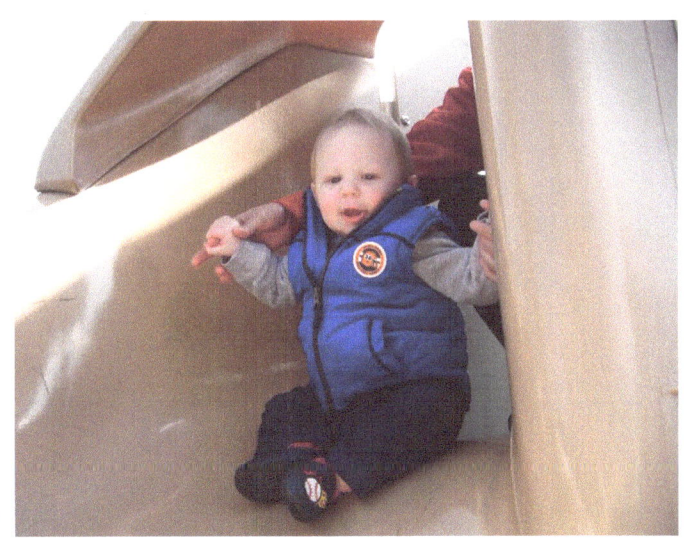

subject?

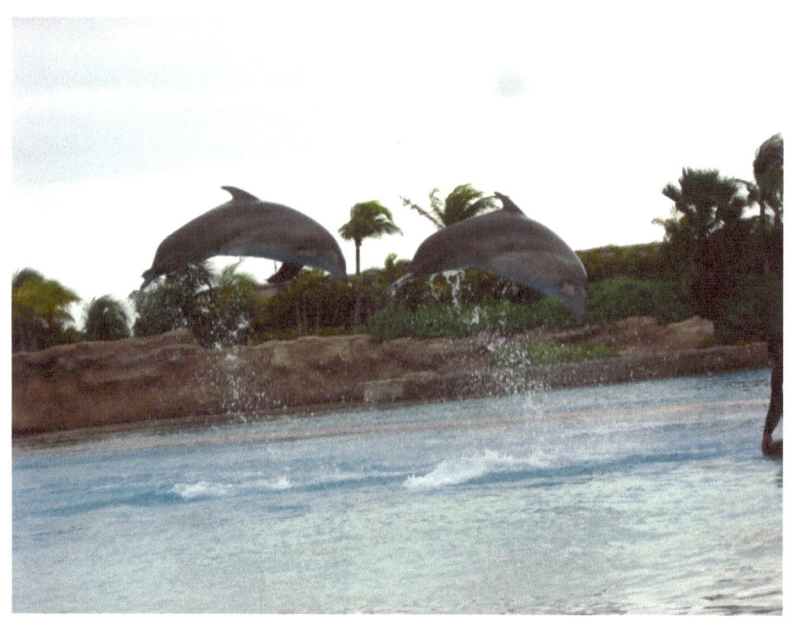

Movement of water adds dimension to your photos. If you're near water, add waves crashing on the beach, water running over rocks, a creek, a lake or a small waterfall. Even a puddle can make an interesting addition to a picture, especially with a ripple in it caused by a drop of water or a bug. Bare feet remind us of carefree summer days. Water and sand reflect light and brighten photos.

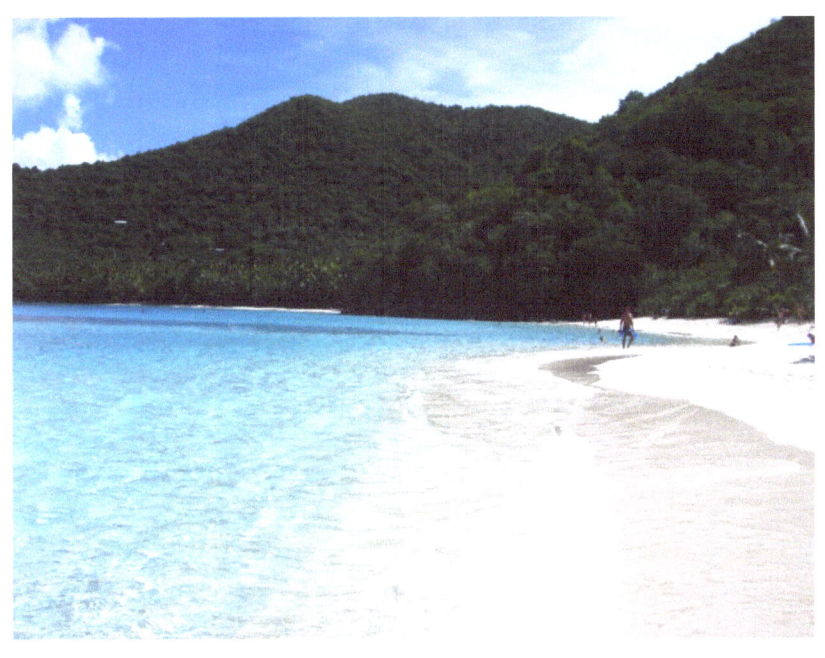

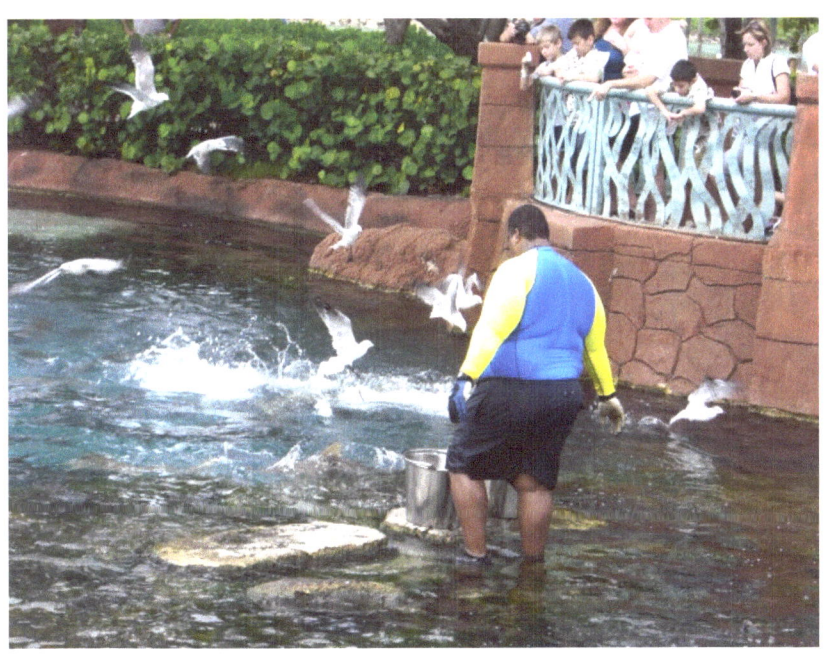

Your Surroundings

Consider shooting the things around you. This requires looking at them differently. Do you have a garden? What's in your backyard? Search for the extraordinary hidden within the ordinary - bushes or twigs in their fall colors, flowers budding, or maybe the setting sun peaking through the branches of a tree.

Is there a park near by? Go for a walk. Take pictures of a kid making funny faces, a dog chasing a ball or even his tail, or a cat playing with a loose ribbon.

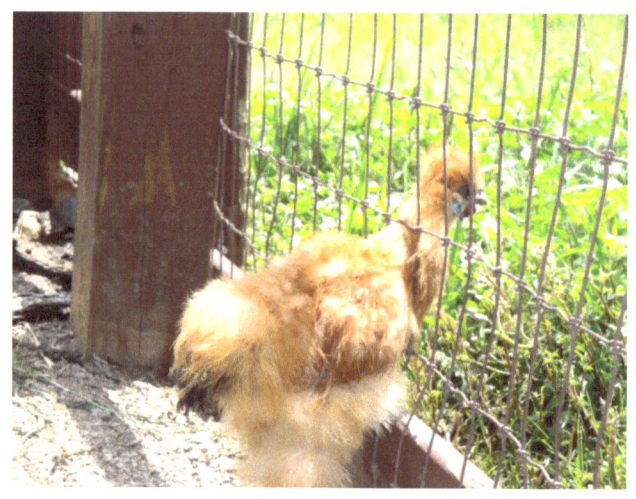

Focus in on the blades of grass in your front lawn. You may even discover an unusually colored bug. Piles of rocks give texture to the picture. You know your child (or husband) wants to climb on them, anyway. Take advantage of it.

Take pictures in the rain. Raindrops make interesting additions to plants, as well as fixed objects. People's faces display unusual expressions when it's raining.

<u>Babies</u>

Your baby is very cute, and nothing makes a parent prouder than sharing pictures of their new child. Everybody loves looking at pictures of babies, too. If you have a little one in the house, get your camera ready and start sharing those cute baby pictures today. The more pictures you have the more fun you will have showing your precious pictures. Here are some great ideas to help you take better shots of your baby.

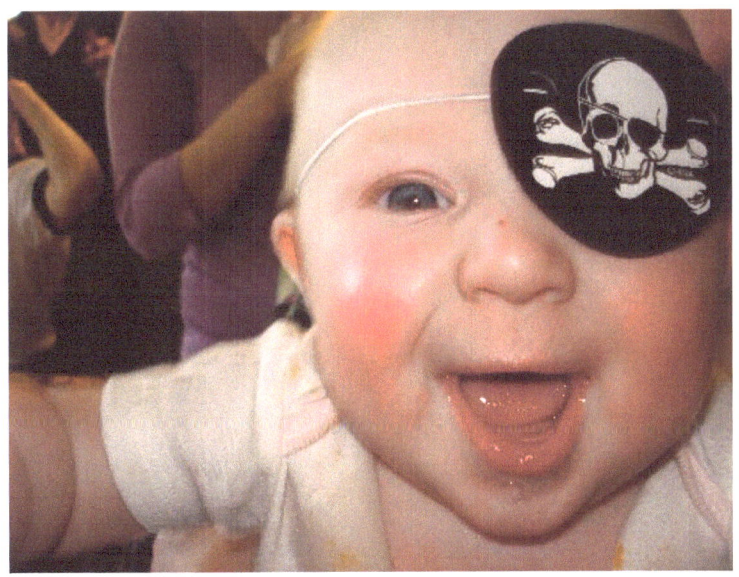

You can never know when your baby will do something entertaining or do something for the first time. For that reason, you always need to have your camera nearby and ready to go. That means making sure you have plenty of film if you use a film camera and making sure your have enough room on your memory stick or card if you use digital. You will also want to make sure that you have enough battery life in your camera at all times. Many parents use more than one camera, too. You can even put a disposable camera in the car or diaper bag for times that are just too cute to pass up.

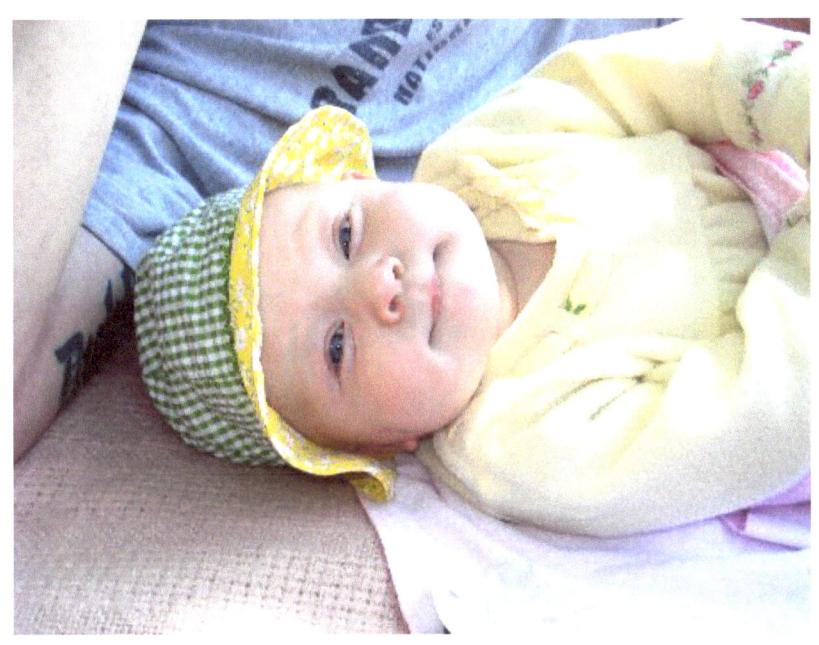

Some of the sweetest pictures of babies are candid shots. You can take memorable pictures of your baby taking a bottle, sleeping and smiling. Candid shots look much more relaxed and natural than posed shots and you will only feel frustrated trying to be posed shots anyway. Babies are notorious for not cooperating for posed pictures. Do not waste your time and take candid shots instead. Do not forget all to take pictures of every part of your baby, such as those fat little fingers or

those tiny toes. Those are always sweet reminders of this young age. If you have a good zoom lens, you can often take great candid shots of your baby from a distance. These are great because your baby will never even know you are there.

You should take many shots of your baby doing the same thing. You may take twenty-five of your babies crawling of the first time, but may only get two or three that are worth using. The more pictures you take, the more you have to choose from the better. It is always best to take more than not enough. A professional as well as armatures know, that not all pictures turn out, especially if you use a high-speed camera. Just keep taking pictures to ensure you capture the moment.

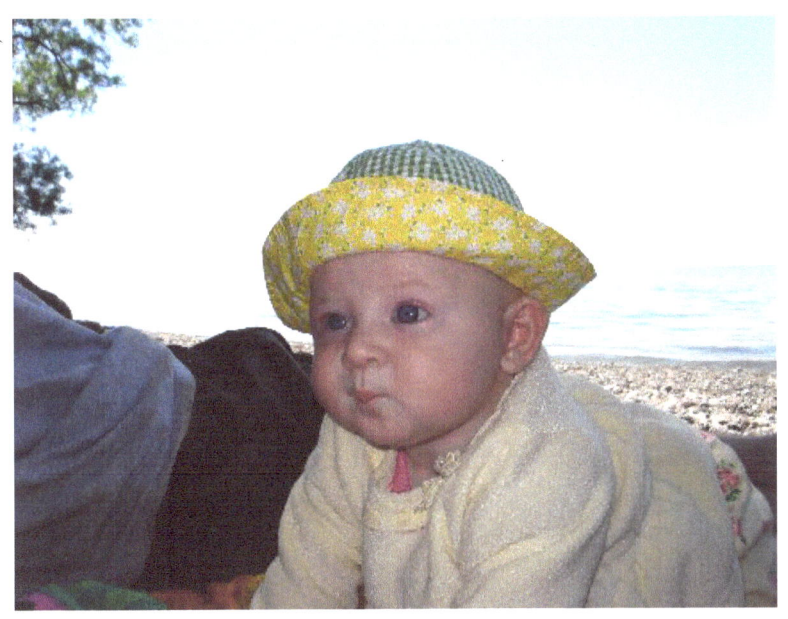

Other People

When taking pictures of people, make sure their hands are away from their faces to keep viewers from looking at fingernails, rings and watches. Outside settings make people look more relaxed and friendly.

Show people involved in activities - talking, singing and laughing. Photograph your family and friends while they are swimming, riding on rides and playing games. With the fast, self-focusing new cameras, you can take great pics of your kids in motion - swinging, sliding or jumping.

Watch the expressions on their faces while they are sipping from straws, licking lollipops or eating ice cream (or, maybe a glass full of cherries).

Pets & Other Living Creatures

You cannot really expect animals to pose for you, can you? So instead, be like paparazzi! Catch them doing something cute and clever and funny. Sneak up on them and start clicking away. You'll be surprised at how good the photos turn out.

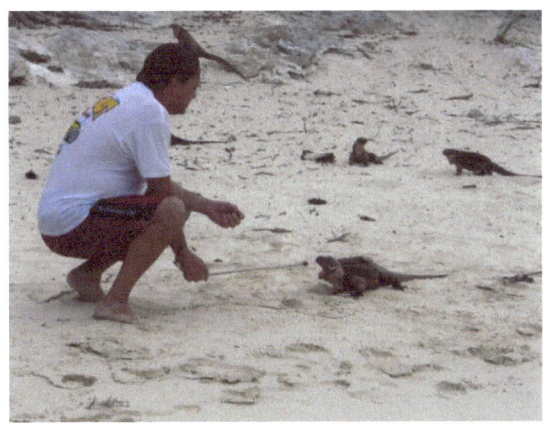

Carefully plan your scenes. If your cat likes to play with toys, then make sure to have loads of them around.

If your dogs like to chew, give them bones to play with or doggie toys they can throw and bite.

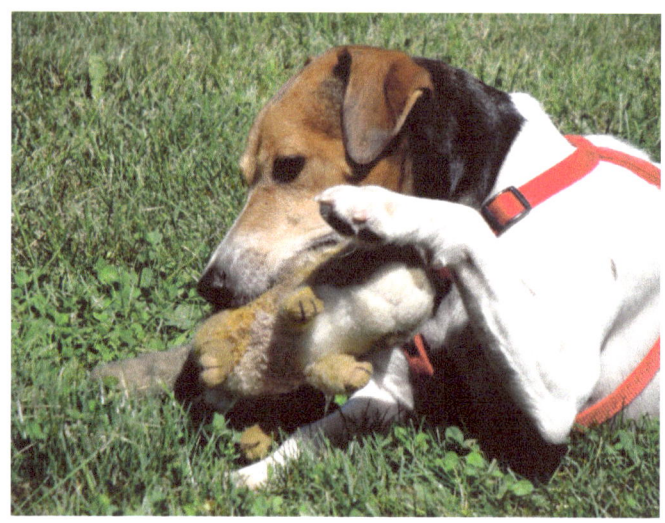

Before shooting animals or bugs, take time to watch their behavior and learn the pattern of their movements. See how they react to your presence, the minimum distance from your camera they will tolerate. The cutest photos are the ones that show the face. Get down to their level, (This works with children as well.) and sit still - ready to capture their spontaneous movements once they become comfortable with you being there. The longer you can wait, the less threatening you appear.

Lighting

Shoot familiar things at different times of day, or in different weather. If you take 2 to 4 pictures of the same subject, each picture is different. You start to learn just what makes it work. Take one picture in the early morning, one in the afternoon when the sun is high, and one at twilight.

Take pictures on sunny days, when it's cloudy, and even when it's raining. Use flash to highlight things in a scene that the camera wouldn't highlight or to balance a bright background. If it's cloudy out, think close-ups. On rainy days, try to keep the sky out of the pictures. Don't shoot with the sun behind your subject. This will

make your subject come out too dark in the picture. Watch out to avoid shadows on faces.

Fluorescent light is the most difficult to work with because it makes color photos look green. When you are indoors, try to get close to natural light from a window or doorway, or get close enough to your subject to allow your flash to light the photo. Natural light coming in from an angle emphasizes textures in photos.

Contrast

Give your pictures contrast. A light subject will have more impact if placed against a dark background and vice versa. Contrasting colors may be used for emphasis, but can become distracting if not considered carefully. Show a sense of scale - big vs. little, such as

a newborn with an older brother, or common objects against unusual ones.

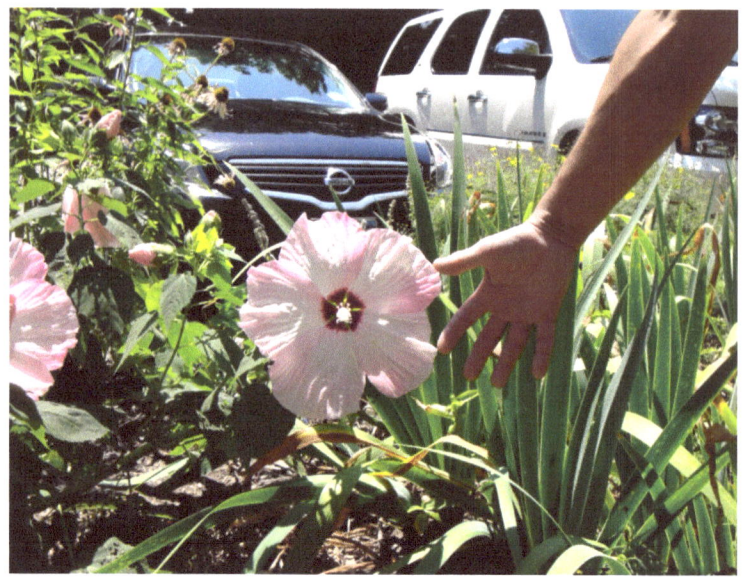

How about taking a picture of a fresh snowfall contrasted against the shadows of the trees and shrubs in the bright morning sunlight or how about some beautiful fall leaves against some multi-colored tree bark? Pay attention to shadows. They sometimes make playful designs on the background. Near water, try to capture the reflection as well as the subject.

Taking a picture of the sun as it is setting can be tricky. Try setting up your camera just before sundown and take the same picture several times - a minute or two apart. Try to get the trail of light from the sun in your picture.

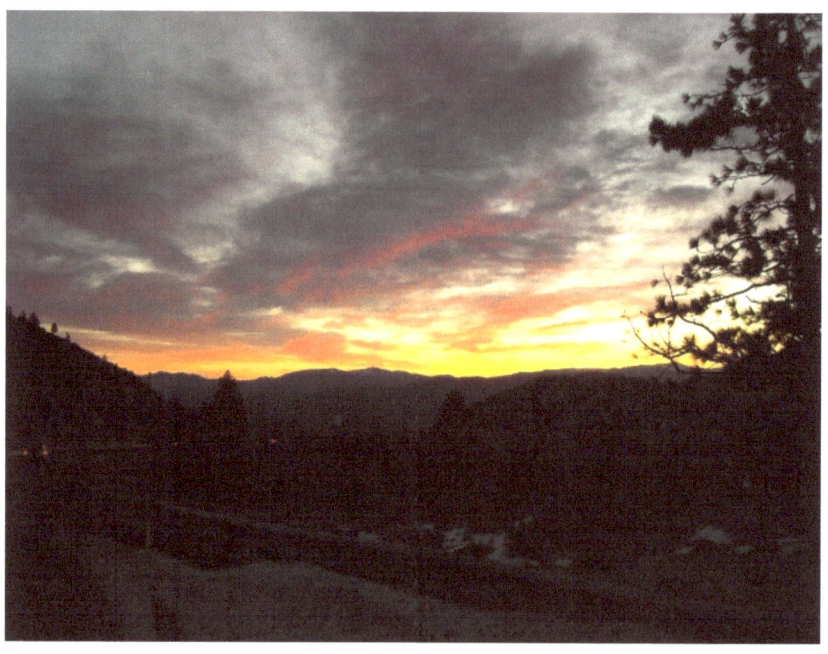

Framing

Frame your picture. A "frame" in a photograph is something in the foreground that leads you into the picture or gives you a sense of where the viewer is.

Try framing your picture by including a branch of a tree, an archway, pieces of furniture, large plants, a window frame, or a doorway - anything to get rid of dull, open spaces.

Look around you - are there unusual shapes in any of the buildings, plants or equipment nearby?

Take a picture under a tree, through a wagon wheel, window, arch or even someone's legs - to be creative. Add people or animals to your scenic pictures. Frame their faces with hats and scarves, jacket hoods, arms and hands stretched overhead, or even long hair.

Take pictures of mirrors with your subject looking into them. Be creative - use a dresser mirror, car mirror or even a hand-held mirror. The mirror becomes the frame for the picture.

Lines

Use natural lines or patterns of nature in your pictures such as ripples on a pond, grass or bushes waving in the wind, layers of brick on a wall, shelves lined with books. Look for geometric shapes and unusual textures such as pebbled sidewalks, straw-scattered floors, or rectangular blocks.

Linear elements such as roads, waterways, and fences placed diagonally are generally perceived as more dynamic than horizontals.

Try photographing rows of boats in a marina, corn growing in a field, wooden slats on a deck or a dock, a fence row with animals behind it. Lines and frames draw the viewer's eyes to the subject.

Off Center

Consider the balance of what you're shooting. Use the "rule of thirds". This is a principle taught in graphic design and photography and is based on the theory that the eye goes naturally to a point about two-thirds up the page.

Keep your point of interest off center. Imagine your photo divided into thirds, from top to bottom and right to left - like a tic-tac-toe board. You want to place your subject where these imaginary lines intersect - never in the center of the picture. Position people's eyes in the upper third of the frame to make them the center of interest.

If the area of interest is land or water, the horizon line will usually be two-thirds up from the bottom. On the other hand, if the sky is the area of emphasis, the horizon line may be one-third up from the bottom, leaving the sky to occupy the top two-thirds.

Angles

Be sure the viewpoint is pleasing. You can often change a picture dramatically by moving your camera up and down , a little to one side or do both. Try turning the camera 90 degrees, taking a vertical shot, instead of horizontal. This creates a new look for the same subject. Use your imagination. Experiment with your camera.

When you shoot a picture facing upward towards your subjects, they appear confident. Shooting downward makes your subjects appear smaller, more vulnerable and innocent. Shooting people from behind shows the world from their perspective. One of the best ways to come up with a great photograph is to find an "unusual" point of view.

Practice Makes Perfect

Learning to take great pictures requires a lot of practice. The more photos you take, the more aware you'll become of your surroundings. Take several pictures of the same things. Take pictures of things you enjoy and people you enjoy being with. Take serious pictures. Take silly ones.

Compare the pictures. Ask friends to comment on them. What do you like or dislike about each of them? Do they tell the story? Experiment and play with it.

So - How do you take good pictures?

**Keep your eyes open -
practice, practice, practice...
and be sure to have fun!**

John 3:16

For God so loved the world that he gave His only begotten Son, that whoever believes in Him shall not perish, but have eternal life.

www.ingramcontent.com/pod-product-compliance
Lightning Source LLC
Chambersburg PA
CBHW041108180526
45172CB00001B/156